Painting in Acrylic

By Varvara Harmon

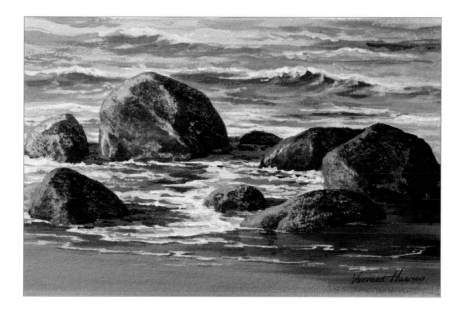

Brimming with creative inspiration, how-to projects, and useful information to enrich your everyday life, Quarto Knows is a favorite destination for those pursuing their interests and passions. Visit our site and dig deeper with our books into your area of interest: Quarto Creates, Quarto Cooks, Quarto Homes, Quarto Lives, Quarto Drives, Quarto Explores, Quarto Gifts, or Quarto Kids.

First Published in 2013 by Walter Foster Publishing, an imprint of The Quarto Group. 26391 Crown Valley Parkway, Suite 220, Mission Viejo, CA 92691, USA. **T** (949) 380-7510 **F** (949) 380-7575 **www.QuartoKnows.com**

Walter Foster Publishing titles are also available at discount for retail, wholesale, promotional, and bulk purchase. For details, contact the Special Sales Manager by email at specialsales@quarto.com or by mail at The Quarto Group, Attn: Special Sales Manager, 100 Cummings Center, Suite 265D, Beverly, MA 01915, USA.

ISBN: 978-1-60058-335-3

Printed in China
20 19 18 17 16

Table of Contents

Introduction

I like to work with a variety of media, and each one works in its own way. Acrylic is a wonderful medium that is perfect for artists who want to try different techniques and styles. Many artists—especially beginners—hesitate to use acrylics because they dry quickly, which means you need to work quickly. This quality is also one of this medium's benefits, as it makes them perfect for plein air painting. With acrylic paint, you can continue working on your project without the need to wait a long time for each layer to dry. You can always add a slow-drying medium to acrylic paints for projects that require more drying time.

Acrylic paint carries endless possibilities for creating a diverse universe of paintings using a variety of techniques to achieve myriad effects. There are many ways to approach painting with this versatile medium. In this book I will concentrate on a realistic painting style.

Each painting is a great journey! Enjoy it!

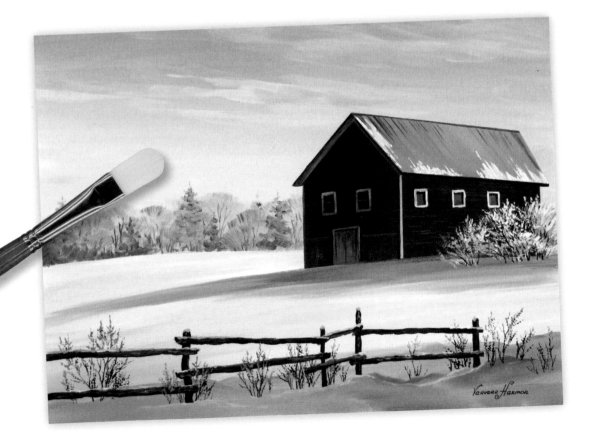

Tools & Materials

To get started with acrylic, you only need a few basic tools. When you buy supplies, try to purchase the best quality you can afford. Better-quality materials are more manageable and produce longer-lasting works.

Paint

Acrylic paint has great quality and depth and comes in a wide variety of colors. It is easy to use, can be mixed with water, is nontoxic, and cleans up easily. Take your time getting to know this medium. Play around with it to understand its consistency and drying time. There are many brands of high-quality paints to choose from and I recommend you purchase the highest quality you can afford. I use a relatively limited palette that allows me to create many color combinations and shades. My color palette contains cadmium yellow light, cadmium yellow medium, yellow ochre, burnt sienna, raw umber, Grumbacher red, alizarin crimson, dioxazine purple, ultramarine blue, cerulean blue, permanent blue light, thalo blue, sap green, Hooker's green, Payne's gray, and titanium white.

Painting Surfaces

I use a wide variety of surfaces for my paintings—stretched canvases, canvas boards, gesso boards, watercolor paper, and watercolor board. For painting with heavier strokes, I prefer to work on well-primed, commercially prepared and stretched canvases or primed gessoboards. For painting with glazing techniques, I use 300-lb. watercolor paper or watercolor board. Watercolor paper is available hot pressed or cold pressed. Hot-pressed watercolor paper has a fine-grained, smooth surface, with almost no *tooth*, or texture. This surface is great for glazing and washing techniques, where you do not want to see the texture of the paper. Cold-pressed watercolor paper has a textured surface, which creates a grainy effect. It is great if you want to use this quality to show texture in your painting.

Palette

There are many acrylic palettes available on the market. It is very important to keep acrylics moist while you are working on the painting. For that reason, I prefer a "stay-wet" palette. It has a foam pad that keeps the palette wet and your paints moist. When you are done with a painting session, you can seal the palette with its lid to protect the paint from drying and keep it usable for a few days.

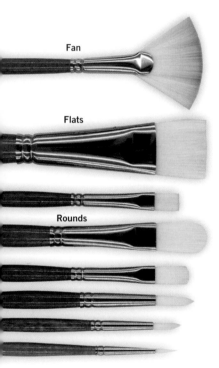

Fan

Flats

Rounds

Brushes

There is a wide range of acrylic paintbrushes designed specifically for this medium. The quality of your brushes is important for achieving the best results, so buy the best brushes that you can afford. It's okay to start out with more affordable brushes and upgrade as you get more comfortable with the medium. Here are several brush shapes that I use:

Round brushes are good for touch-ups or more detailed work.

Flat or **filbert** brushes hold plenty of paint and are good for applying thick layers. Both flat and filbert brushes are great for painting large surface areas, as well as creating thin, straight lines. These brushes are useful for blending colors and creating well-defined brush strokes on your surface.

A **fan** brush has a flat profile, spread like a fan. This brush is ideal for creating a patterned texture or wispy lines.

Cleaning Your Brushes

Having the right brush is essential, but it is equally important to keep your brushes in good shape. When you are done using your paintbrush, make sure you wipe off any excess paint with a painting rag or a paper towel. Rinse your brush in lukewarm water with soap or brush cleaner. Make sure the water temperature isn't too hot because that can damage the brush. If you do not clean your brushes properly and fail to

remove all of the excess paint, it will dry on the filaments of your brushes and the bristles will stiffen. Washing your brushes properly will help them last much, much longer.

Easels

You will need a simple easel to hold your canvas in place as you paint. Acrylic paintings are usually painted with the canvas tilted at a slight angle backward (about 15–20 degrees). It's important that your easel has a clamp at the top and a holder on the bottom. A good choice is a box easel that can hold a rectangular palette, brushes, and paints inside. If you prefer, you can use a tabletop or a standing French easel, with legs that fold out like a tripod.

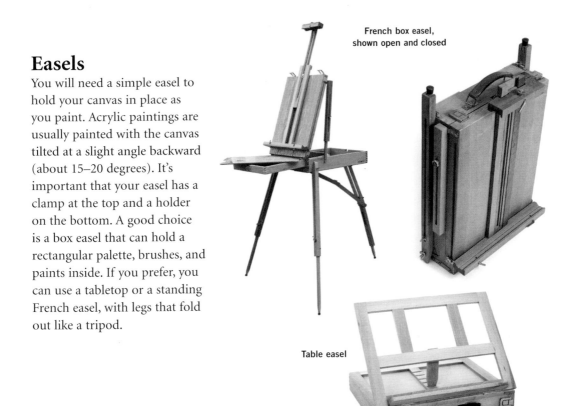

French box easel, shown open and closed

Table easel

Additional Supplies

Some additional supplies you'll want to have on hand include: paper towels or painting rags to clean and dry the brushes; paper and pencils for drawing, sketching, and tracing; an eraser; and a bowl or jar of water to rinse your brushes. You may want to have a toothbrush, palette knife, and sponge available for creating special effects, removable tape for protecting areas of your paintings, and artist tape to secure watercolor paper to hard surfaces. I also recommend masking fluid to preserve the white areas of your paper when you paint using the watercolor technique, as well as a retarder to increase the working time of your paints. Lastly, I like to keep a plastic card, such as an old credit card, on hand to use for scraping paint.

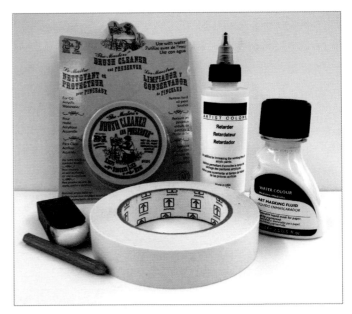

Color Basics

Before you begin painting, it's important to know basic color theory. Color plays a huge role in the overall mood or "feel" of a painting, as colors and combinations of colors have the power to elicit various emotions from the viewer. On these pages, you'll learn some basic color terms. You'll also discover how colors affect one another, which will help you make successful color choices in your own paintings.

Learning the Basics

The color wheel is a circular spectrum of colors that demonstrates color relationships. Yellow, red, and blue are the three main colors of the wheel; called *primary* colors, they are the basis for all other colors on the wheel. When two primary colors are combined, they produce a *secondary* color (green, orange, or purple). And when a secondary and primary color are mixed, they produce a *tertiary* color (such as blue-green or red-orange). Colors that lie directly opposite one another on the wheel are called "complements," and groups of colors that are adjacent on the color wheel are referred to as "analogous."

Warm yellow Cool yellow

Secondary: Orange Secondary: Green

Warm red Tertiary: Blue-green

Cool blue

Cool red Warm blue

Secondary: Purple

The Color Wheel This handy color reference makes it easy to spot complementary and analogous colors, making it a useful visual aid when creating color schemes.

Exploring Color "Temperature"

The colors on the color wheel are divided into two categories: *warm* (reds, oranges, and yellows) and *cool* (blues, greens, and purples). Warm colors tend to pop forward in a painting, making them good for rendering objects in the foreground; cool colors tend to recede, making them best for distant objects. Warm colors convey excitement and energy, and cool colors are considered soothing and calm. Color temperature also communicates time of day or season: warm corresponds with afternoons and summer, and cool conveys winter and early mornings.

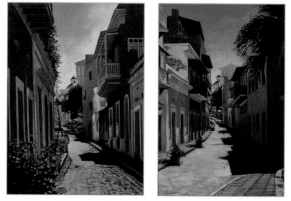

Seeing the Difference in Temperature Above are two similar scenes—one painted with a warm palette (left), and one painted with a cool palette (right). The subtle difference in temperature changes the mood: The scene at left is lively and upbeat; at right, the mood is peaceful.

Using Color Complements

Selecting your palette based on a pair of complementary colors can add a vibrancy to a painting that's difficult to attain with other color combinations. When placed next to each other, complementary colors (such as green and red) make one another appear brighter and dynamic because they seem to vibrate visually.

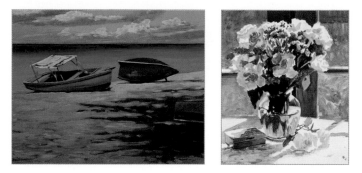

Applying Complementary Color Schemes The paintings above demonstrate two different complementary color schemes. The boat image (left) utilizes a blue and orange scheme that makes the sand appear to glow beneath the sun. The vase and roses (right) have a yellow and purple color scheme, causing the flowers to radiate with intensity—even in the soft light from the window.

Mixing Neutrals

Neutral colors (browns and grays) are formed either by mixing two complementary colors or by mixing the three primaries together. By altering the quantity of each color in your mix or by using different shades of primaries, you can create a wide range of neutrals for your palette. These slightly muted colors are more subtle than those straight from the tube, making them closer to colors found in natural landscapes. Below are a few possibilities for neutral mixes using the colors of a basic palette.

Prussian blue + alizarin crimson + Naples yellow

Phthalo blue + cadmium red light + cadmium yellow light

Light blue-violet + burnt sienna + yellow ochre

Understanding Value

Value is the lightness or darkness of a color or of black, and values are used to create the illusion of depth and form in two-dimensional artwork. With acrylic paints, artists generally lighten paint mixes with lighter paint, such as white or Naples yellow. However, acrylic can also be applied in thin washes like watercolor, in which case the white of the paper beneath the paint acts as the lightener. Creating a value scale like the one below will help you determine how the lightness or darkness of a color is altered by the amount of water added.

Value Scale Creating value scales like the ones above will help you get a feel for the range of lights and darks you can create with washes of color. Apply pure pigment at the left; then gradually add more water for successively lighter values.

Acrylic Techniques

Basic Techniques

There are myriad techniques and tools that can be used to create a variety of textures and effects. By employing some of these different techniques, you can spice up your art and keep the painting process fresh, exciting, and fun!

Flat Wash This thin mixture of acrylic paint has been diluted with water. Lightly sweep overlapping, horizontal strokes across the support.

Graded Wash Add more water and less pigment as you work your way down. Graded washes are great for creating interesting backgrounds.

Drybrush Use a worn flat or fan brush loaded with thick paint, wipe it on a paper towel to remove moisture, and then apply it to the surface using quick, light, irregular strokes.

Mask with Tape Masking tape can be placed onto and removed from dried acrylic paint without causing damage. Don't paint too thickly on the edges—you won't get a clean lift.

Lifting Out Use a moistened brush or a tissue to press down on a support and lift colors out of a wet wash. If the wash is dry, wet the desired area and lift out with a paper towel.

Wet-into-Wet Apply a color next to another that is still wet. Blend the colors by stroking them together where they meet, and use your brush to soften the edges to produce smooth transitions.

Special Techniques

Below are a few special techniques I like to implement in my paintings using some different brushes and tools.

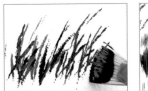 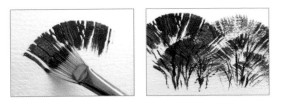

A fan brush is perfect for quickly and easily painting trees. I start at the top of the tree and move the brush down to create the tree's crown-shaped semicircle. Then, using a small round brush, I add the details of the trunk and branches.

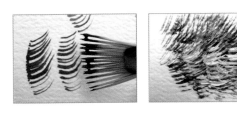

With the same fan brush you can also create realistic animal fur. Load the brush with paint and make a few strokes, lifting the brush at the end of each stroke. Repeat to build layers, creating a light, fuzzy look.

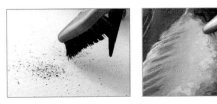

You can also use the fan brush to create grass blades and flower stems. This wildflower-grassy look can be achieved by touching the canvas with just the edge of a fan brush that has been loaded with paint.

This spattering technique is very easy to do. First load a toothbrush with paint. Then run the bristles of the toothbrush across the blade of a palette knife. This technique is perfect for creating the effect of splashing water or the rough texture of rocks and sand.

You can utilize the tooth of rough paper when rendering natural textures. For example, the roughness of rocks can be achieved in just a few steps. First paint your rock color on the paper. Let it dry for a minute and then use any thin plastic card to lightly scrape the paint away from the painted rock, revealing the grain of the paper.

Using a palette knife, you can create the texture of a tree trunk, branches, or blades of grass just by scraping wet paint on the canvas.

Establishing Atmospheric Perspective

In this painting of a peaceful mountain scene, we'll practice how to create atmospheric depth in a landscape.

Color Palette
cerulean blue, ultramarine blue, alizarin crimson, Hooker's green, Payne's gray, yellow ochre, burnt sienna, and titanium white

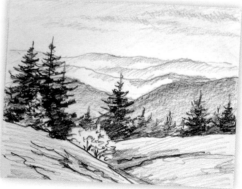

Step 1 I create a small sketch to establish my composition.

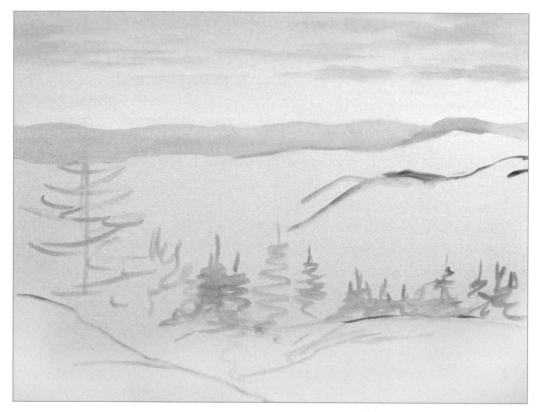

Step 2 I place the composition on the canvas using thin lines with a mixture of cerulean blue and titanium white. Then I start working at the top of the canvas. I use different shades of a mixture of cerulean blue and titanium white for the sky. Then I add ultramarine blue and alizarin crimson to the sky mixture to create the clouds. Next I paint the most distant mountains using the same color palette with a bit more blue.

12

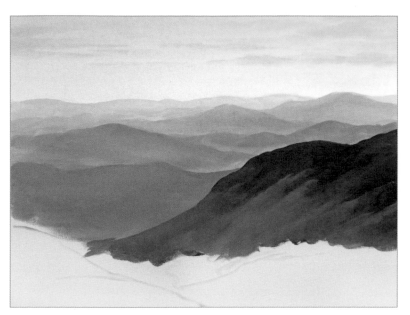

Step 3 For the mountains closer to the foreground, I add Hooker's green to the mixture I used in step 2. These mountains will be darker and sharper. Because these mountains are still a good distance from your point of view, the cool bluish color will be dominant so they recede into the background.

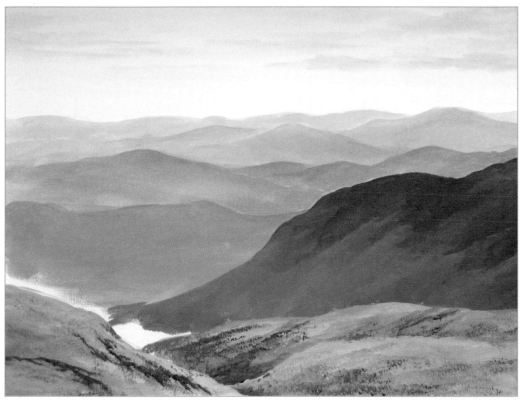

Step 4 Using a 1" flat brush I paint the base color for the rock ledge in the foreground. I mix yellow ochre, burnt sienna, and titanium white to paint the parts of the ledge that are in sunlight. I use ultramarine blue, alizarin crimson, and Payne's gray for the portions in shadows. Using the same brush, and keeping it flat, I go over the painted rocks and create texture by tapping the brush. I use smaller brushes to add cracks and more texture to the ledges.

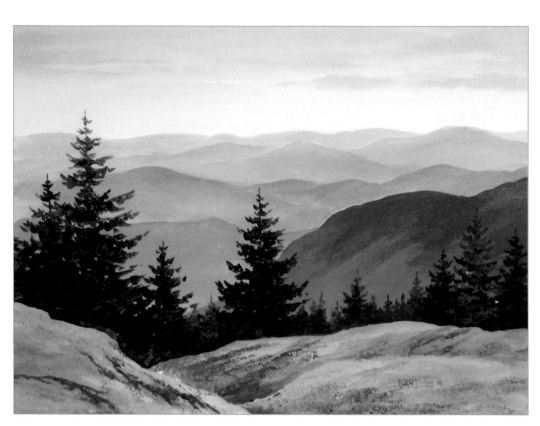

Step 5 I mix ultramarine blue, Hooker's green, and Payne's gray for the first step in painting trees. Remember that the trees at a greater distance will be smaller and lighter in value than the trees closer in the foreground. Add a little bit of titanium white to the mixture for the lighter-value trees. After this step all the trees have their shapes, but still look flat and one-dimensional.

Details

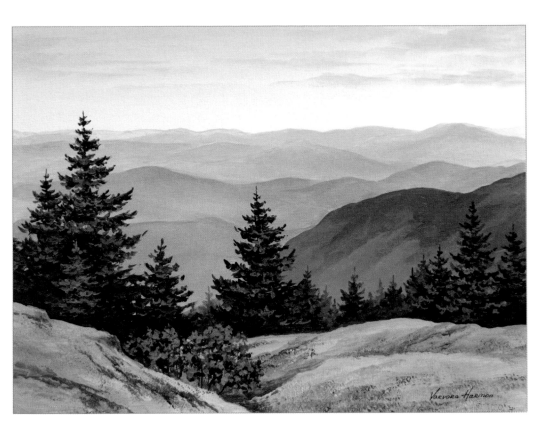

Step 6 When the trees are dry, I start adding new layers for depth. To emphasize branches that are in the sunlight, I use Hooker's green and burnt sienna first. Then, as a final step, I add highlights using a mixture of Hooker's green, yellow ochre, and titanium white. I also add a little bush between the rocks just before I finish the painting.

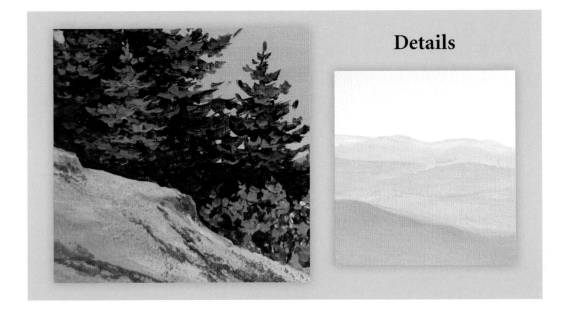

Details

Building Up Layers

This coastal scene contains multiple layers—sky, ocean, trees, rock, and the foreground flowers. This is a great project to practice working with a variety of elements.

Step 1 I start the process with a quick sketch to get an idea of how the composition will appear in the final painting.

Step 2 I like to use light pencil marks to indicate the horizon. I start painting the sky, using cerulean blue, ultramarine blue, and titanium white. While the sky is wet, I paint the ocean to make the transition between the two areas visible but gradual. Remember that on a hot summer day, the horizon on the ocean is quite diffused because the atmosphere contains a lot of moisture.

Horizon line

Step 3 I continue working on the part of the ocean closer to shore. For this area I add Hooker's green and Payne's gray to my color palette from step 2. I also add some wave lines to the ocean surface.

Step 4 I move to the foreground, where I place the base color for the rock ledges using yellow ochre, burnt sienna, and a little bit of ultramarine blue and titanium white. Then I add more Payne's gray and ultramarine blue to my mix and paint the shore that is visible just above the ledge. I also add some crashing wave details along the shoreline. I use the toothbrush spattering technique to create textures on the rock. (Cover the rest of the painting with paper to protect it from spatter overspray!) Then I use a small brush to add some cracks to the rock surface.

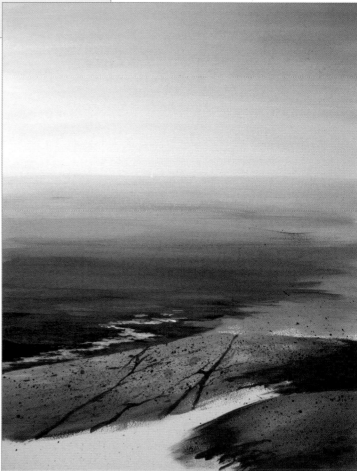

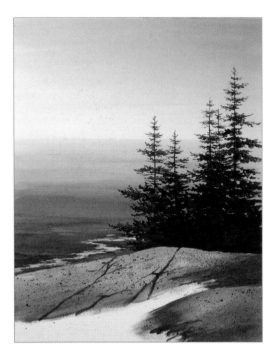

◄ Step 5 I mix ultramarine blue, Hooker's green, and Payne's gray for the trees. I start by painting a thin trunk line and work my way from top to bottom on the foliage. Remember to leave the shore visible.

► Step 6 I finish painting the trees by adding three-dimensional effects. I do this by emphasizing the shape of the branches that are in sunlight, using Hooker's green and burnt sienna first and then adding a lighter mix of Hooker's green, yellow ochre, and titanium white.

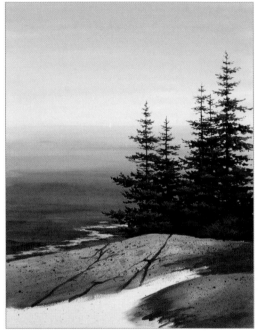

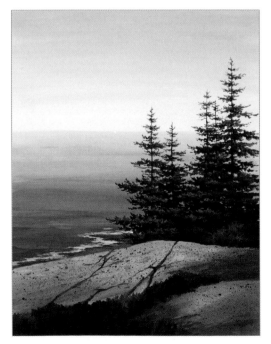

◄ Step 7 For the undercolor of the grass, I use ultramarine blue, Hooker's green, Payne's gray, and burnt sienna. Do not mix this paint into a uniform color; instead try to create patches of grass using different color variations.

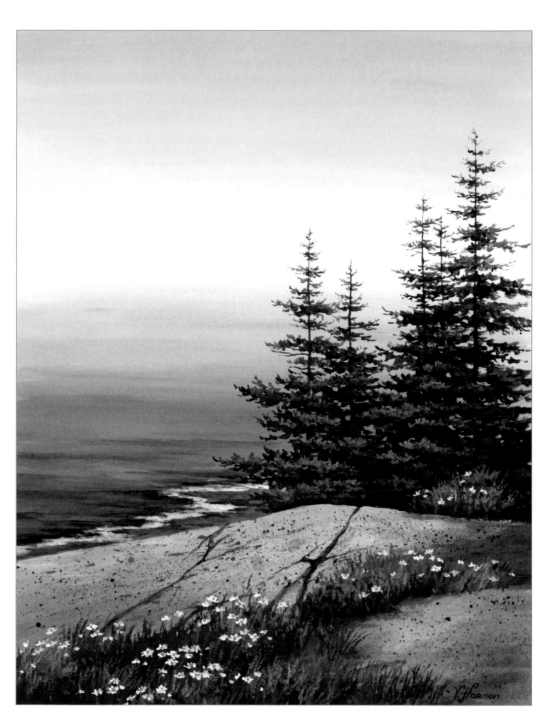

Step 8 To create grass blades and flower stems I use a fan brush. I use a similar color palette to that in step 7 and add some additional yellow ochre, cadmium yellow, and titanium white for brighter, lighter colors in the grass. I finish the grassy area with wildflowers, using cadmium yellow, dioxazine purple, alizarin crimson, and titanium white. As an artist you can paint any wildflower combinations that you wish!

Painting Autumn Foliage

Fall colors are vibrant and fun to paint. In this project we'll explore how to render fall foliage, as well as realistic tree bark.

Color Palette
ultramarine blue, dioxazine purple, alizarin crimson, Payne's gray, cadmium yellow medium, yellow ochre, burnt sienna, Grumbacher red, Hooker's green, and titanium white

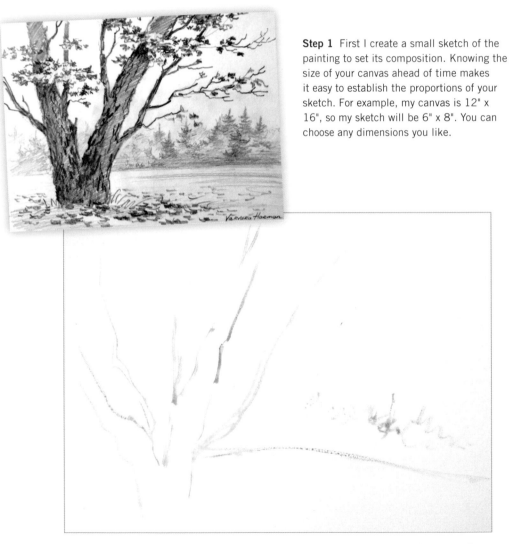

Step 1 First I create a small sketch of the painting to set its composition. Knowing the size of your canvas ahead of time makes it easy to establish the proportions of your sketch. For example, my canvas is 12" x 16", so my sketch will be 6" x 8". You can choose any dimensions you like.

Step 2 Using a little ultramarine blue, I paint very light lines for the horizon, background forest, and foreground tree. These lines are very general; you do not need to get into too many details at this point.

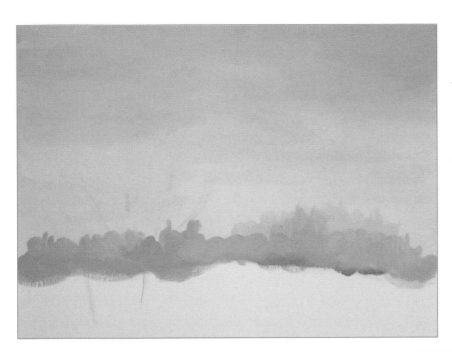

Step 3 I start working on the sky using titanium white, ultramarine blue, alizarin crimson, and a little bit of Payne's gray to create the gray, foggy effect.

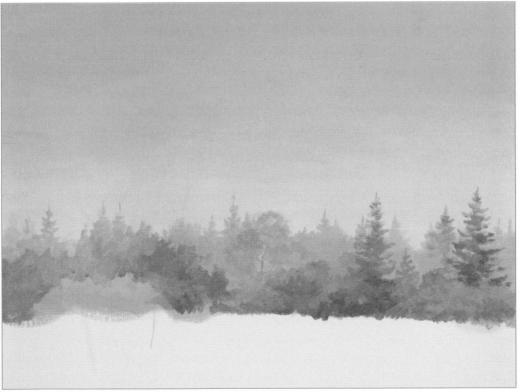

Step 4 Next I paint the background forest using all the colors I just used for the sky, but I add a little bit of Hooker's green. I paint the trees farthest away light bluish–purplish colors and the closer trees darker, with some greenish and reddish hues to suggest autumn foliage. Remember that on a foggy day any objects in the distance will have predominantly light and midtone value and will not have contrast lines.

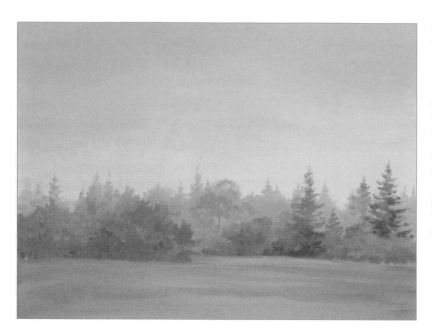

Step 5 I finish the background by painting in the field, using ultramarine blue and Hooker's green as a base color. Then I add some of the purple mixture I used for trees in step 4 to the more distant parts of the field and yellow ochre to the foreground to suggest distance.

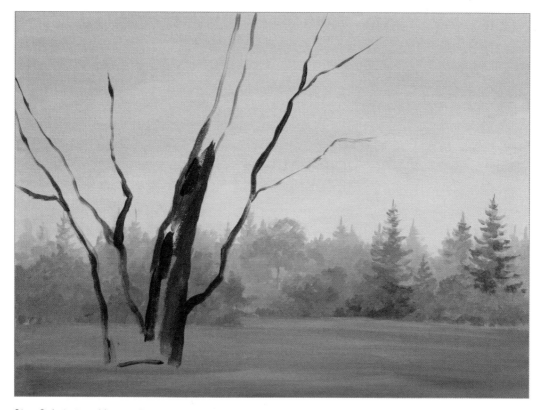

Step 6 I start working on the tree by outlining the trunks and the major branches using Payne's gray and burnt sienna.

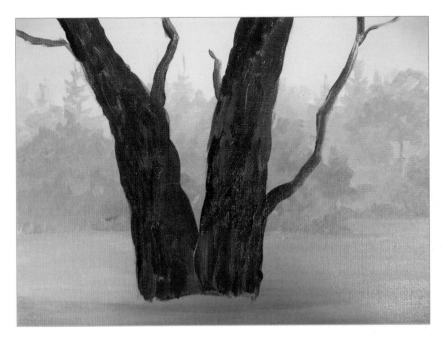

Step 7 I use Payne's gray and burnt sienna as the base colors of the trunks and branches. On the lighter (sunlit) side, I use more burnt sienna, while on the shaded sides, I use more Payne's gray.

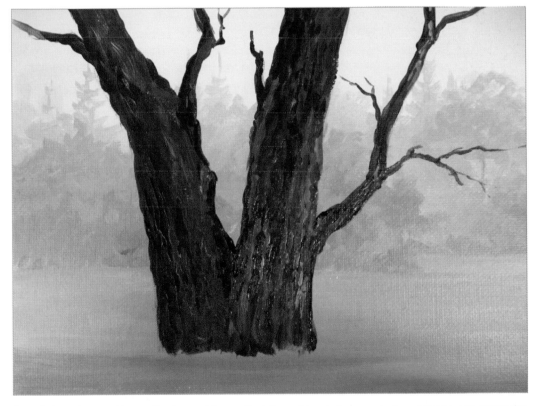

Step 8 I continue working on the tree, adding vertical lines of burnt sienna and ultramarine blue to create the effect of cracks in the tree bark. I also add yellow ochre lines on the lighter side of the tree.

23

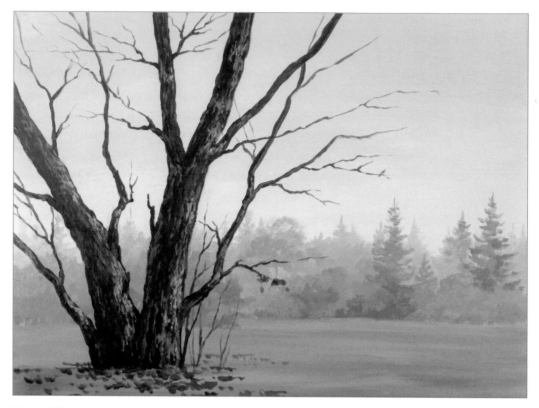

Step 9 I finish the tree by adding moss to the trunks and major branches. I combine a bluish-grayish mixture of ultramarine blue, Payne's gray, and titanium white for the shaded sides and a greenish-yellowish mixture of yellow ochre, Hooker's green, and titanium white for the lighter sides. I also start the leaves on the branch and on the ground, using a mix of Payne's gray, dioxazine purple, and alizarin crimson.

Step 10 I continue painting foliage. On the background leaves I use my leaf mix from step 9. For the foreground leaves, I use a lighter mix of burnt sienna, Grumbacher red, and yellow ochre.

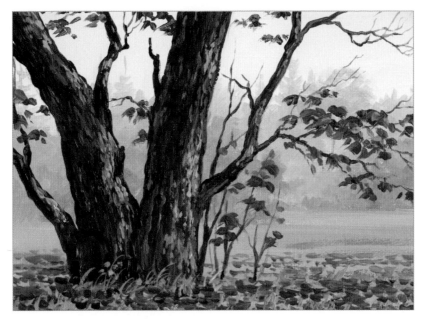

Step 11 Using the same paint combinations from step 10, I add leaves on the ground, along with some grass elements painted with Hooker's green and yellow ochre.

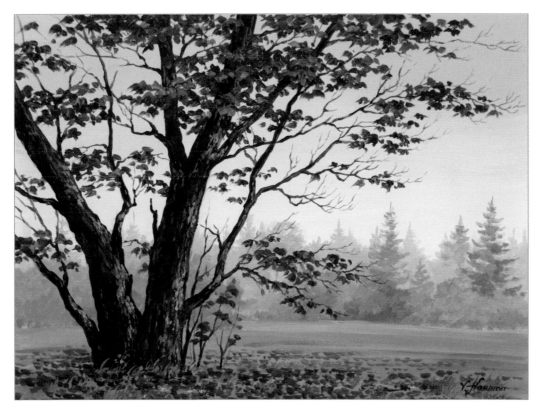

Step 12 I finish the painting by adding details of small brunches using Payne's gray. Be sure to include some branches without leaves to achieve the desired autumn effect!

Producing Crisp Lines

This bright red barn really stands out next to the white snow. When painting structures like this it's important to get clean, crisp lines. To do so, we'll work with our removable tape.

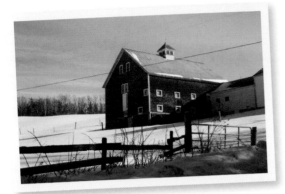

Color Palette
ultramarine blue, cerulean blue, alizarin crimson, cadmium yellow medium, burnt sienna, Payne's gray, Hooker's green, and titanium white

Step 1 After doing a brief sketch, I start with the sky. I use ultramarine blue, cerulean blue, alizarin crimson, cadmium yellow medium, and titanium white. For the sky closer to the horizon, I mix titanium white with cerulean blue and add ultramarine blue as I move up to the top of the canvas. While the sky is still wet, I mix titanium white, alizarin crimson, and cadmium yellow medium and paint the clouds.

Step 2 Next I paint in the background trees using a fan brush. Start the brush at the top of the tree and move down to create the tree's crown-shaped semicircle. I use a mixture of ultramarine blue, alizarin crimson, burnt sienna, and Payne's gray. Note that I have left an unpainted area on the right side of the canvas for the barn.

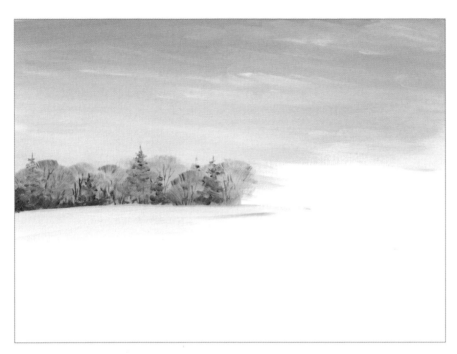

Step 3 I finish the background forest by adding some evergreen trees, using ultramarine blue, burnt sienna, and Hooker's green. These trees are in the distance so the color will not be bright and sharp; I keep them in midtone values.

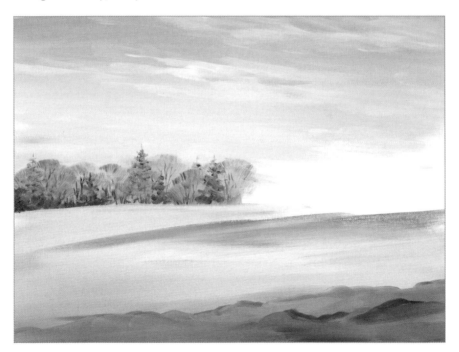

Step 4 In the afternoon light snow reflects the colors of the clouds in the setting sun. So I want to paint the snowy field using the same color palette I used for the clouds: titanium white, alizarin crimson, and cadmium yellow medium. In the shaded areas of snow, I add ultramarine blue to my mix, using less for the lighter areas and more for the darker shadow areas.

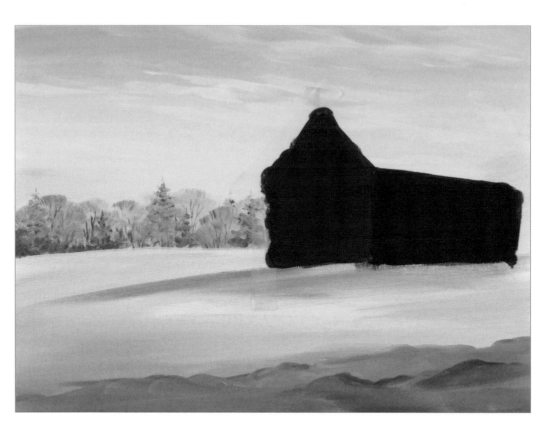

Step 5 I transfer the barn's shape from my sketch onto the canvas. Then I use removable tape (see step 6) to cover the space around barn and protect it. Now I don't have to worry about detailing the straight edges of the barn's sides and roof. For the warm, sunlit side of the barn I use burnt sienna with a little bit of alizarin crimson and cadmium yellow medium. I use a mixture of burnt sienna, alizarin crimson, and ultramarine blue for the shaded front of the barn.

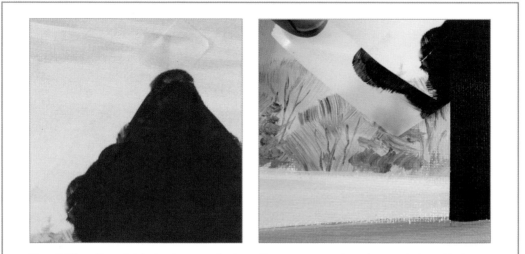

Step 6 When the paint is dry, I remove the tape. Now you can see how sharp and clean this leaves the edges of the barn against its background.

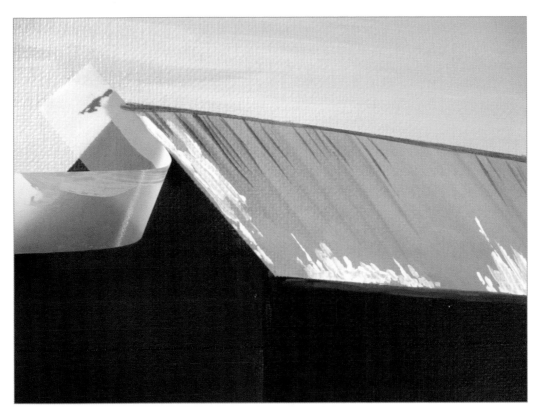

Step 7 I use the same technique to paint the roof. I use ultramarine blue, cerulean blue, alizarin crimson, burnt sienna, Payne's gray, and titanium white to create multiple shades of gray to paint the roof. Then I add the dark gray lines and white for the snow. When the paint is completely dry, I remove the tape.

Artist's Tip
You can paint the barn without taping the edges first, but this technique makes it much easier (and faster) to create strong edges.

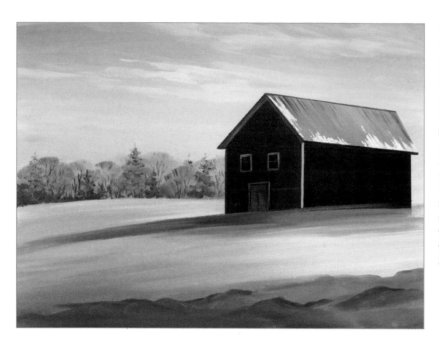

Step 8 Now I add some details to the barn, including the windows and door. For these details you can use any combination of the gray shades you used on the roof; just make them a little bit darker because they are in shadow. I also add some color to the walls of the barn to vary the texture and add visual interest.

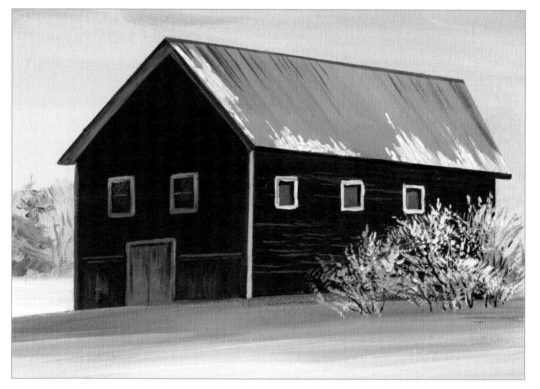

Step 9 Next I paint the snow-covered trees in front of the barn. I start by painting the branches with ultramarine blue, Payne's gray, and titanium white. Then I paint the trunks, using Payne's gray. I finish the trees by adding highlights on the light sides, using a very light mixture of titanium white, alizarin crimson, and cadmium yellow medium.

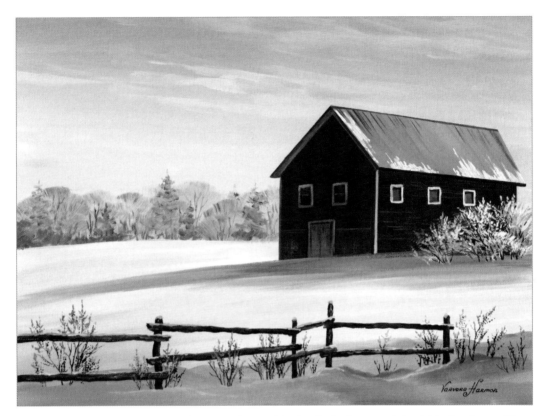

Step 10 In this last step, I add the fence and the small bushes in the foreground. I paint in the shape of the fence and bushes with mixtures of burnt sienna and Payne's gray. Then I add ultramarine blue and titanium white to the mixture and create some lighter details on the fence. As a finishing touch, I add some snow on the bushes and fence with a mixture of ultramarine blue and titanium white.

Working with Glazes

Glazing is a great acrylic technique that involves placing multiple thin layers of paint on the paper. These thin layers are perfect for building up colors and adjusting the temperature and hue of your color gradually.

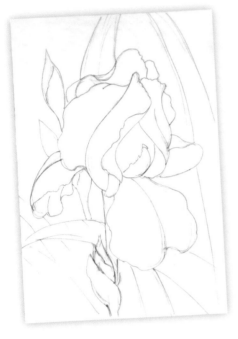

Color Palette
ultramarine blue, dioxazine purple, cerulean blue, cadmium yellow medium, cadmium yellow light, and Hooker's green

Step 1 First I draw my composition on tracing paper at the same size I want to paint. I work out any changes I want to make before transferring the composition onto watercolor paper. Take your time with this step and make changes on your tracing paper to avoid extra lines on the watercolor paper. I like to lift a corner of my tracing paper every once in a while to make sure my drawing is transferring correctly.

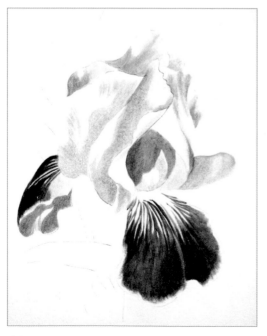

Step 2 For the first layer of my glaze, I use a combination of ultramarine blue and dioxazine purple to paint in the shaded and shadowed areas of the iris. I also add a touch of cerulean blue to the shadows on the white petals to add interest. I dilute the paint with paint retarder so I can create gradual color change effects without leaving paintbrush marks.

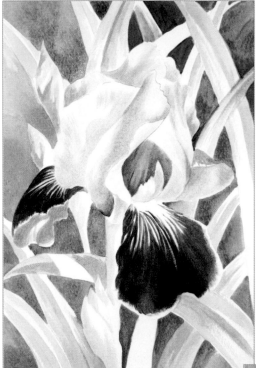

Step 3 Using the same colors, I paint the leaves as well as the background. I decide to add more leaves to my composition to fill it out more.

Step 4 I use a small flat brush to cover everything except the flower with a thin layer of cadmium yellow medium. Then I mix some paint retarder into my paint and apply an additional layer on the light areas of the iris leaves to show the warmth of sunlight.

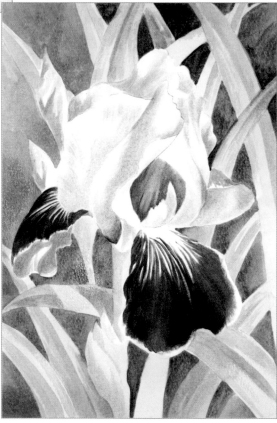

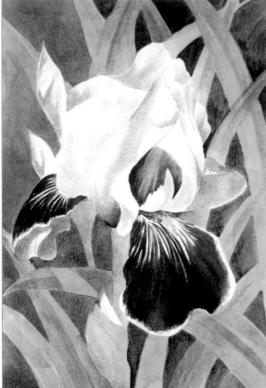

Step 5 When the previous layer is completely dry, I apply a glazing layer of Hooker's green to the leaves and background. At this stage the painting looks good, but it does not have enough depth and contrast. I add more details to the center of the flower with cadmium yellow medium.

Step 6 For the final steps, I add more cerulean blue, ultramarine blue, and dioxazine purple glazing layers to the petals of the iris to emphasize the shaded parts and deepen the purple. I also add layers of cadmium yellow light and Hooker's green to the leaves. Lastly I apply a glazing layer of ultramarine blue and dioxazine purple to the background leaves to tone them down and create more contrast between the flower and the background.

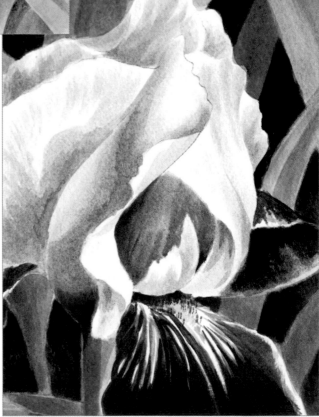

Step 7 After making a final pass around the painting to make any adjustments, I add my signature and am done!

Taking Artistic License

Painting wildflowers is fun! They provide an endless array of colors, shapes, and compositions to experiment with. I really like this photo of pink Echinacea flowers, but it's a little busy. As the artist, you have the freedom to change or tweak your painting—you don't have to paint exactly what you see! I decide to focus on four main flowers.

> **Color Palette**
> ultramarine blue, alizarin crimson, cadmium yellow medium, yellow ochre, burnt sienna, sap green, and titanium white

Step 1 I establish the composition by drawing the flowers to determine the placement of each blossom. I do not add any other details because I'm going to cover the canvas with an underpainting. If you want more details, draw them on a separate piece of paper to use as a guide.

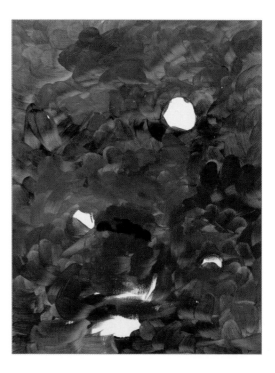

Step 2 I lay down my first background layer with a big flat brush, using ultramarine blue, yellow ochre, burnt sienna, and sap green. I cover the whole background, just leaving small spaces for the centers of the flowers.

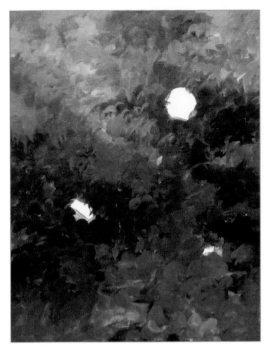

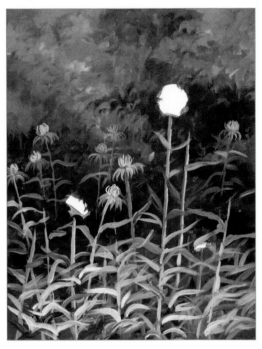

Step 3 I finish the background with a second layer, using all the same colors but adding cadmium yellow medium and titanium white to create lighter values. I use a medium flat brush as well as round brushes to create the soft background forest and grass effect.

Step 4 I add the stems and leaves, using a few different medium- and small-sized round brushes and various mixtures of cadmium yellow and sap green to achieve depth and variety. I use a lighter mix for the stems and leaves in the foreground and darker mixes for the flowers towards the back, so they appear to recede into the background. Then I add a few small buds to some of the stems.

Painting the Buds Painting small flower buds can be achieved in three simple steps.

1. Use a small round brush to paint the top of the bud with a mixture of cadmium yellow medium and sap green with titanium white.

2. Then add a couple of strokes with a mixture of alizarin crimson and titanium white to emphasize the color of future petals.

3. Lastly, add some small leaves below the flower bud, using a mix of cadmium yellow medium and some sap green.

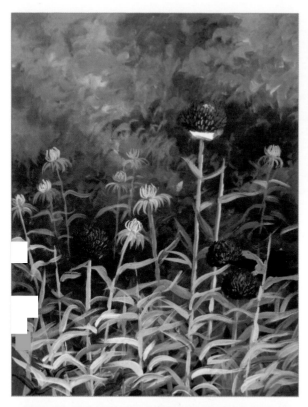

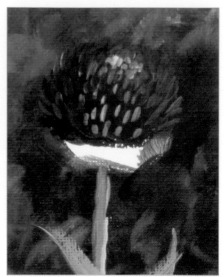

Step 5 Next I paint the base color of the flowers' centers, using a combination of alizarin crimson, burnt sienna, and ultramarine blue. I use more burnt sienna and ultramarine blue on the shadow side of each center. Then I paint the stamens with a fine round brush, using alizarin crimson, burnt sienna, cadmium yellow medium, and titanium white. I use short strokes and leave space between the stamens so the base color shows through.

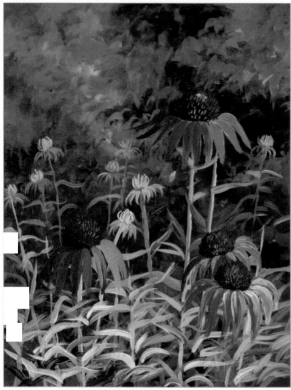

Step 6 Next I place the base color of the flower petals. On the sunlit side, I use a mixture of alizarin crimson and titanium white. For the parts in shadow, I add ultramarine blue to my mix and use less titanium white.

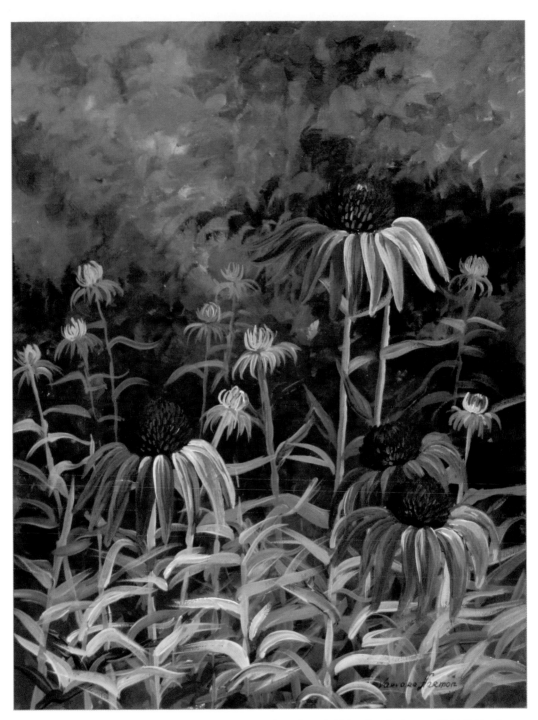

Step 7 I finish by adding more details to the flower petals and emphasizing the shadows and highlights. For the shaded parts I lay on more alizarin crimson and ultramarine blue. For the highlights I use a cool mix of titanium white and ultramarine blue. To bring out the highlights on the sunlit side I use a warm mix of titanium white and cadmium yellow medium. I just use a few strokes, letting my base color show for dimension.

Painting a Still Life

In this lesson we'll learn how to paint a still life setting with pears. Remember that both composition and light are essential for any still life. This photo has a beautiful pattern of light, interesting composition of the three pears, and a dramatic, dark background.

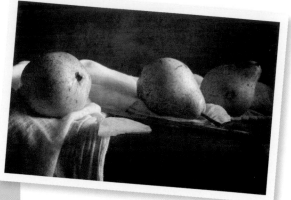

Color Palette
ultramarine blue, alizarin crimson, cadmium yellow medium, yellow ochre, burnt sienna, Payne's gray, sap green, titanium white, and permanent blue light

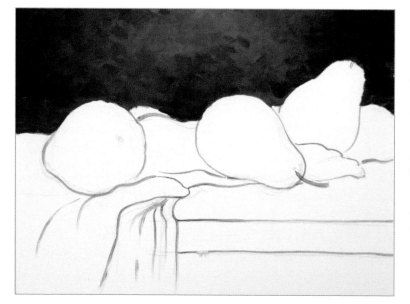

Step 1 I draw directly on my canvas with burnt sienna. Then I start on the background. With a big filbert brush, I lay down the underpainting, using ultramarine blue, burnt sienna, yellow ochre, Payne's gray, and sap green. On the cooler left side I use more ultramarine blue, and on the warmer right side I use more burnt sienna.

Artist's Tip
If you're not comfortable drawing right on the canvas yet, you can do it on tracing paper first and then transfer your drawing onto the canvas.

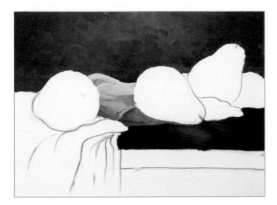

Step 2 For the table, I use the same palette I used for the background. Then I use a mixture of burnt sienna, Payne's gray, and yellow ochre to paint the pear's reflection. I also start working on the fabric, using ultramarine blue, alizarin crimson, and Payne's gray for the cool areas. I create the warm area that reflects the pears using alizarin crimson, cadmium yellow medium, and sap green.

Step 3 The fabric is a great exercise for studying colors. Notice how it reflects colors from all the surrounding objects. In the shade areas I paint cool colors, using ultramarine blue, alizarin crimson, and Payne's gray. Where the fabric is close to a pear it shows the warmth of reflecting light from the fruit. I use a "pears palette" to create these reflections, using ultramarine blue, burnt sienna, yellow ochre, alizarin crimson, cadmium yellow medium, and sap green. Then I use these colors to paint the base color for the center pear, paying close attention to the areas of shadow to achieve the proper values.

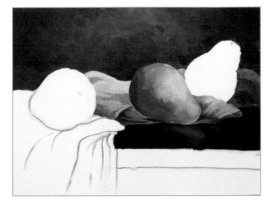

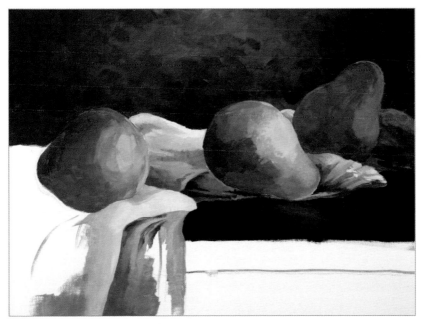

Step 4 I paint the base colors on the other two pears, using the same pear palette from step 3. At this point I'm just creating the shapes and applying the base color so I can see the color relationships between the subjects. I save my highlights for later. I start the fabric that drapes over the edge of the table, using the same colors from step 2.

41

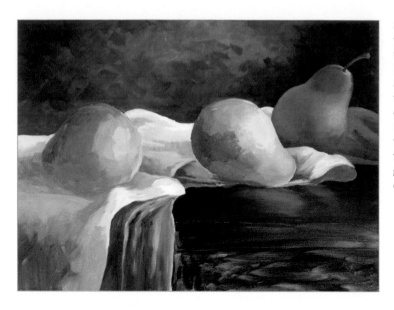

Step 5 Now we're ready to finish the underpainting for the rest of the canvas. I continue blocking in the areas of shadow and light in the fabric and on the bottom edge of the tabletop. The painting looks rough, but the underpainting gives us the overall value and color guidelines we'll follow to complete it.

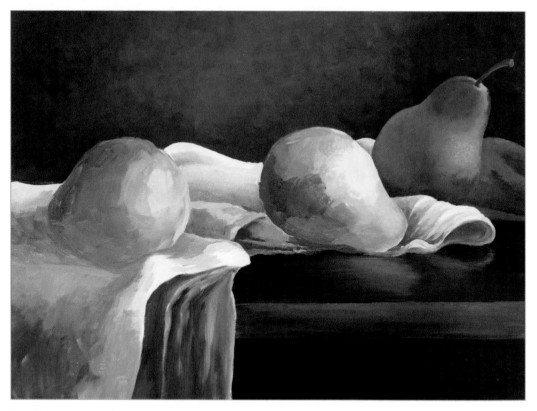

Step 6 I want to touch up the background and table before focusing on the pears. I use the same palette from step 1. On the table I use a lighter mix on the forward-facing edge, and I emphasize the reflection of the pear on its side with cadmium yellow medium and sap green, blending softly into the table. Don't be afraid to experiment and make adjustments to your color mixes to modify to your taste.

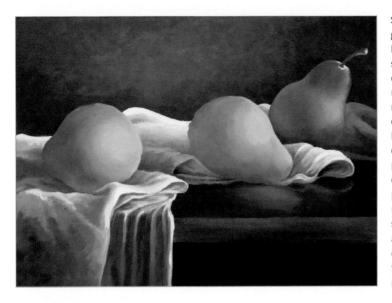

Step 7 Following the color guidelines I blocked in before, I repaint all the pears, striving for gradual and delicate color transitions. I use more cadmium yellow medium and yellow ochre on the lighter parts, more burnt sienna and alizarin crimson in the reddish portions, and more sap green on the greenish sides of the pears. I use a combination of ultramarine blue and burnt sienna to fill in the shaded areas. I finish working on the cloth, creating smoother color transitions and adding some more details in the folds.

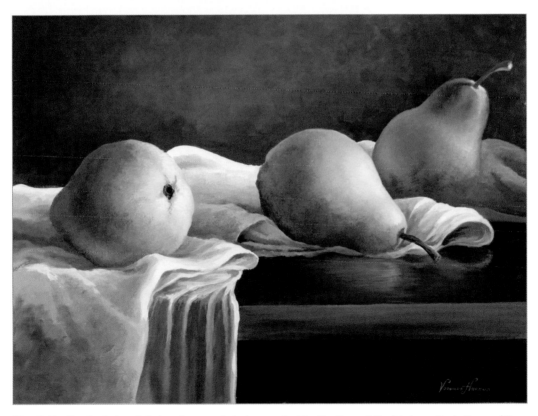

Step 8 For the final step, I darken the pears' shadows and add reflections of the fabric on the bottoms of the pears. I also add highlights on the lit portion of the pears, using cadmium yellow medium mixed with a bit of titanium white. I add details such as the pears' stems and sepals using my darker pear color mix. Finally I add some color to the pears' and cloth's reflections on the table, as well as a little more contrast in the folds of the cloth near the pears.

43

Creating Texture

▶ The details of a building's structure can be very interesting and unique, with a combination of textures and colors. In this painting, we get to experiment with creating the textured stucco wall, delicate lace curtains in the windows, and soft foliage.

Color Palette

thalo blue, ultramarine blue, alizarin crimson, dioxazine purple, cadmium yellow medium, yellow ochre, burnt sienna, Payne's gray, sap green, and titanium white

Step 1 I draw my initial outline, studying the proportions carefully. Then I paint the stucco wall, using alizarin crimson, yellow ochre, burnt sienna, and Payne's gray. Use a big flat (or filbert) brush to fill in the background, leaving the window and shutters untouched. To create rough texture, I dab a sponge all over the paint.

Step 2 When the paint is completely dry, I place removable tape around the window and shutters to protect the area and to get straight edges. It's important to let the paint dry completely so the tape does not destroy your painting when you remove it.

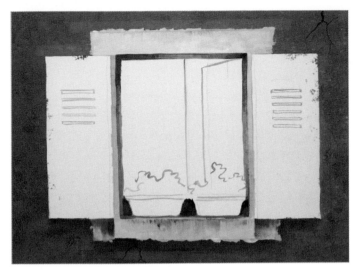

Artist's Tip

Resist the temptation to use a heat source—such as a hair dryer—to speed up the drying process when using tape. The tape will "cook" into the paint underneath it and then remove the paint when you lift off the tape!

Step 3 To paint the window frame, I use a combination of yellow ochre, Payne's gray, and titanium white. To create the old, weathered effect I place some darker lines, using Payne's gray. I also use Payne's gray for the shaded areas in the middle of the window and under the shutters. I also add the cracks in the stucco at top right and under the window.

Step 4 When the paint is dry, I remove the tape from around the window frame and place it around the shutters. I paint the shutters with a medium filbert brush and a mix of thalo blue, Payne's gray, and titanium white. I paint a darker shade of blue in the middle of the shutters to create the shadows from the flowers I plan to add. I also add some details with Payne's gray, such as the fine lines between the individual boards and the horizontal slots in the middle of each shutter. When the paint is completely dry I remove the tape.

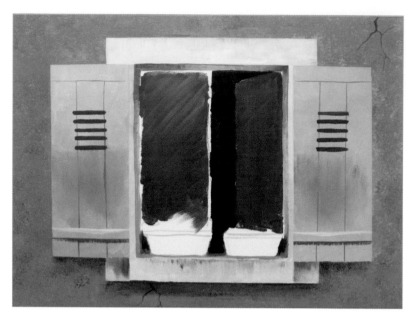

Step 5 Next I move to the wooden window frame and glass. I paint the open window with Payne's gray. For the closed window, I add thalo blue and titanium white to Payne's gray to show light reflection.

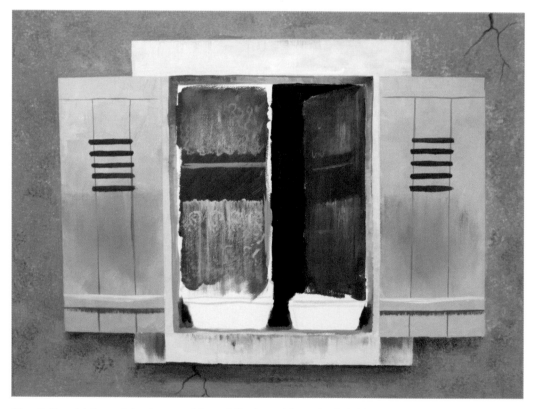

Step 6 To paint the curtains I use a mixture of titanium white and a little bit of thalo blue. Using a relatively dry mixture of paint and a flat brush, I drag the brush, barely touching the canvas. The rough texture of the canvas helps create the fabric's see-through effect. I add the lacy pattern details of the curtains with a small brush, using a darker mixture on the open window.

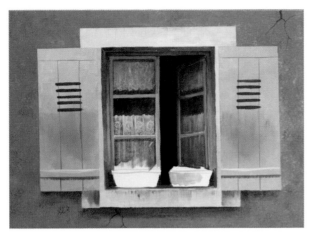

Detail

Step 7 I finish painting the wooden frame that divides each pane of glass, using the same blue shutter mix from step 4. You can use tape to keep the lines straight if you desire.

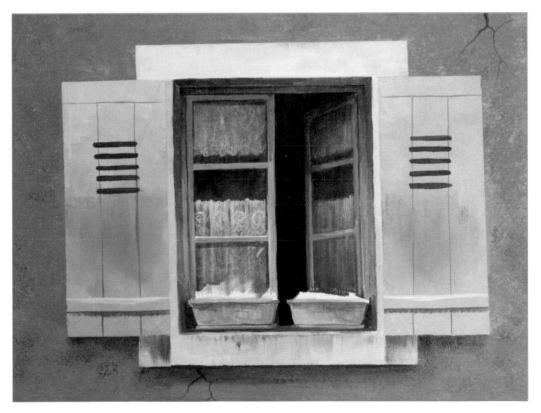

Step 8 For the flowerpots on the windowsill, I use yellow ochre, Payne's gray, and titanium white. I use more Payne's gray to depict the shadows that will be cast by the flowers.

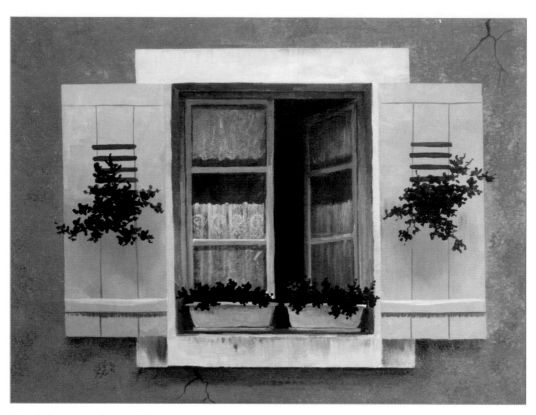

Step 9 I start painting the foliage with a dark mix of ultramarine blue, Payne's gray, and sap green to create the shapes of the flower bunches. Because leaves will cover the flowerpots on the shutters, I don't bother to paint them. I just paint the foliage right on the shutters.

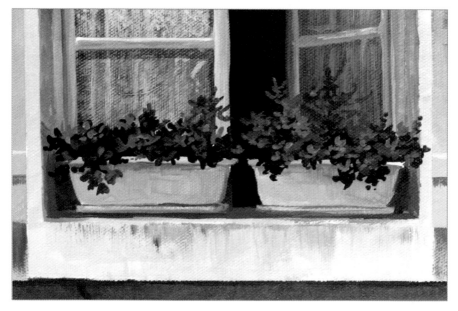

Step 10 Next I add midtones and highlights to the leaves, using sap green, cadmium yellow medium, and yellow ochre with a bit of titanium white.

Step 11 I paint the flowers on the windowsill, using alizarin crimson. For the flowers on the shutters I use dioxazine purple.

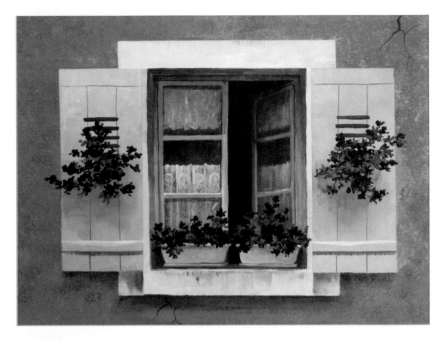

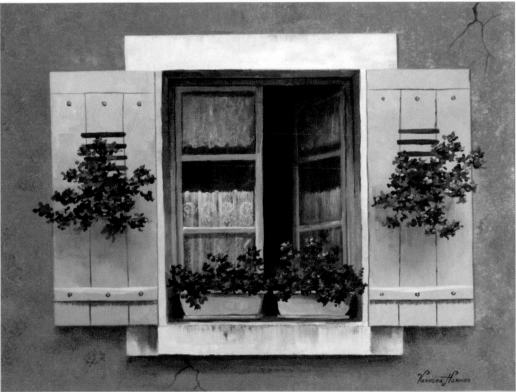

Step 12 To add dimension to the flower blossoms, I add cadmium yellow medium and titanium white to my purple mixes from step 11 and paint another layer on select flowers, leaving some dark for depth. I finish up by adding smaller details, such as the nails in the shutters, and emphasizing the shadow lines by making them slightly darker.

49

Painting Beach Rocks

Rocks come in a variety of shapes, size, and textures. In this project we'll look at weather-worn beach rocks and how to render their gritty, rough texture.

Color Palette
ultramarine blue, cerulean blue,
Payne's gray, burnt sienna,
yellow ochre, Hooker's green,
and titanium white

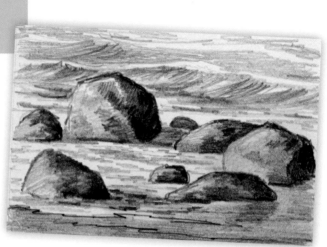

Step 1 I compose my drawing and determine the source of light on the left side. I indicate both the shadows and light on the drawing.

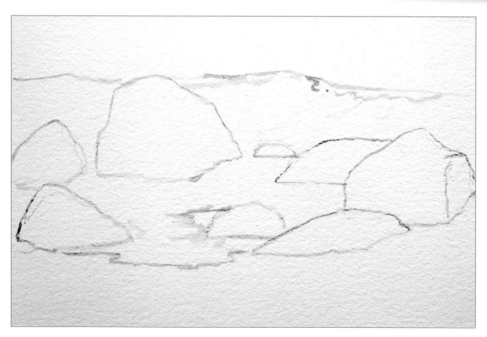

Step 2 I draw the composition on watercolor paper. Then I go over my lines with very thin mixtures of burnt sienna and ultramarine blue.

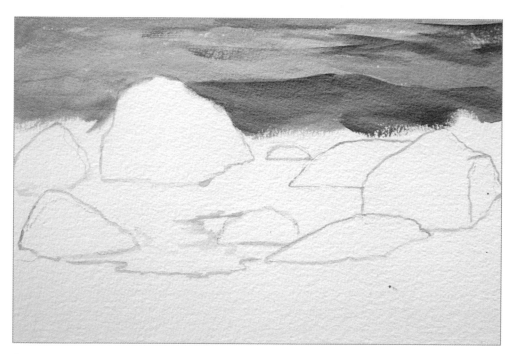

Step 3 I mix cerulean blue, ultramarine blue, Hooker's green, Payne's gray, and titanium white on the palette to create many different shades of blues and greens for the background waves. I paint the waves, making those further back a little lighter, with more cerulean blue.

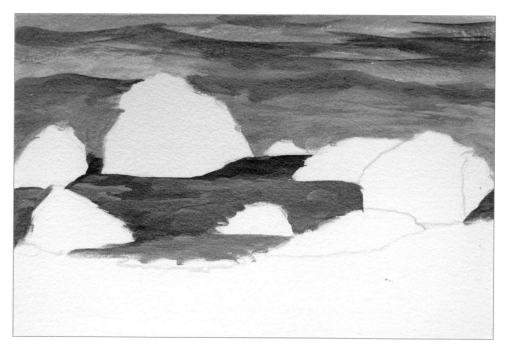

Step 4 The water between the rocks is very shallow and mixed with sand. For a more brownish color, I use a mix of ultramarine blue, Payne's gray, burnt sienna, and titanium white.

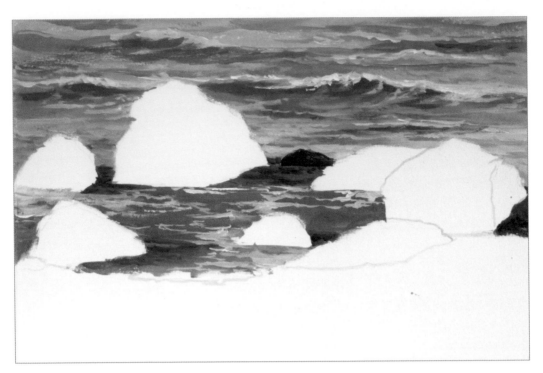

Step 5 I continue working on the waves by adding the shape of the foam on the tops of the background waves and between the rocks. Remember that both the water and foam should be much darker in the shadows of the rocks, so use your darkest mixes for these areas.

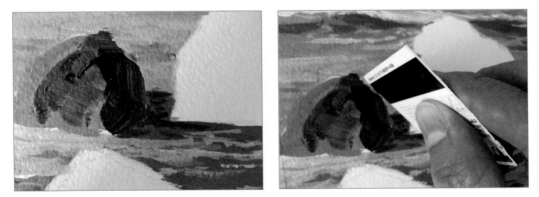

Step 6 On the other side of my palette I place the four colors that I will use to paint the rocks: ultramarine blue, Payne's gray, burnt sienna, and yellow ochre. Working on a single rock at a time, I use yellow ochre to paint the sunlit side of the rock, burnt sienna on the midtone portions, and a mixture of ultramarine blue and Payne's gray on the shaded side. I let the paint dry for a few seconds, and then I use a plastic card to scrape the wet paint from the rock, creating texture.

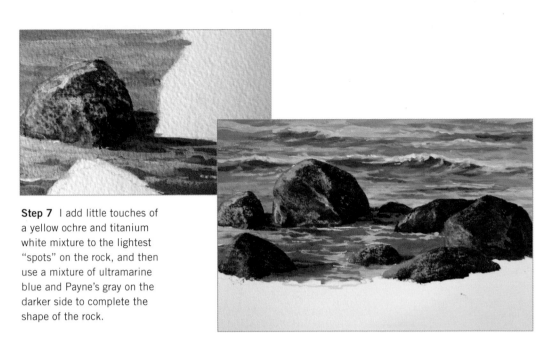

Step 7 I add little touches of a yellow ochre and titanium white mixture to the lightest "spots" on the rock, and then use a mixture of ultramarine blue and Payne's gray on the darker side to complete the shape of the rock.

Step 8 I repeat steps 6 and 7 on each rock, one at a time.

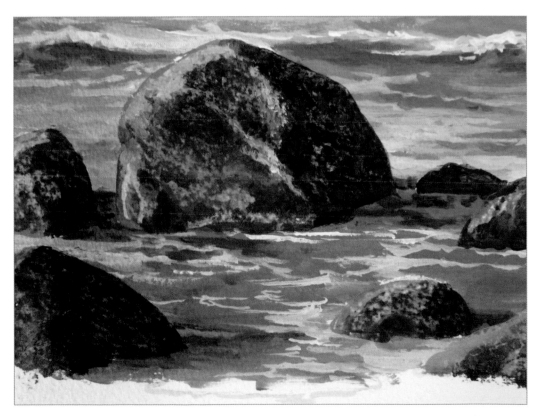

Step 9 I apply the same colors I used to paint the rocks (burnt sienna and yellow ochre) to create the reflection in the water.

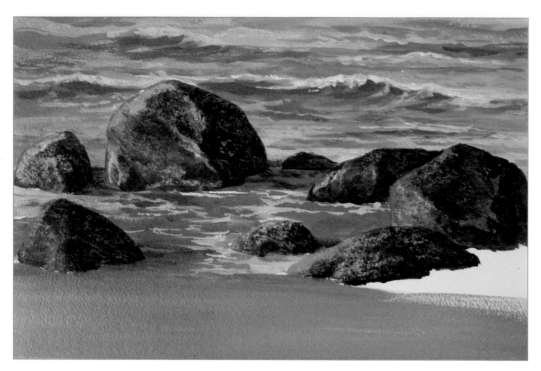

Step 10 Wet sand reflects surrounding colors, including the sky and rocks, so I mix ultramarine blue, Payne's gray, and burnt sienna to paint wet sand showing the sky's reflection. I add more burnt sienna as I move closer to the shore where the sand is drier.

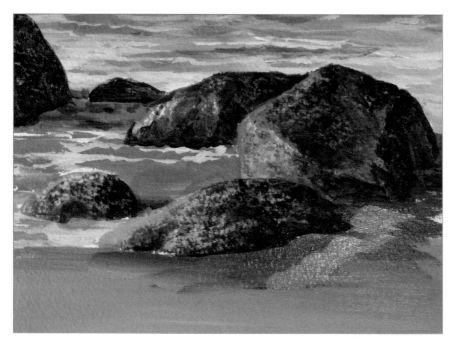

Step 11 To create the rock reflections in the wet sand, I use yellow ochre and burnt sienna. While the paint is still wet, I use a 1" flat brush to smooth the paint, moving it vertically from the rocks towards the bottom of the paper.

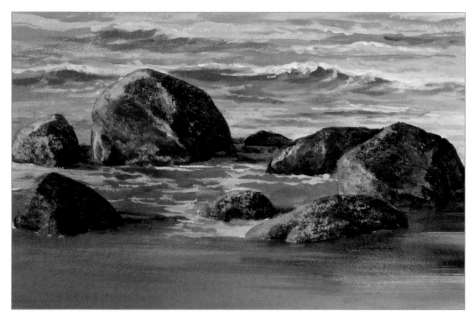

Step 12 Next I make a couple of light, horizontal strokes with the same 1" brush to get rid of the vertical lines. I also add a few horizontal strokes with a light blue mixture to suggest the sky reflecting on the wet sand.

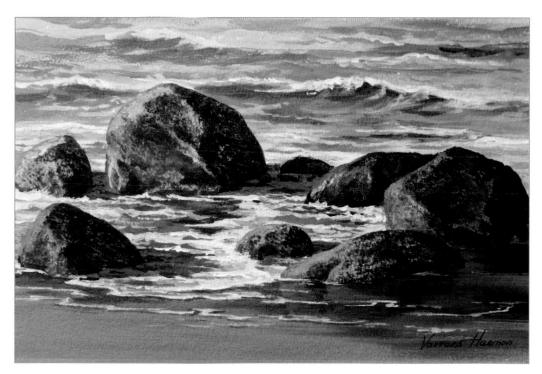

Step 13 In the final step, I add foam to the area of wet sand and on the water between the rocks. In sunlit areas, I use a very light gray-blue mixture and a darker bluish mixture for foam in the rocks' shadows. I finish with titanium white for highlights.

Painting Waves

Ocean waves are dynamic, full of motion, light, and beautiful color transitions. In this project we'll explore how to paint a lively wave.

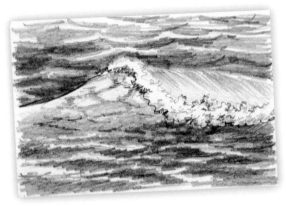

Step 1 First I create a composition drawing. You can do this on any drawing paper, and then transfer it onto your watercolor paper or canvas.

Step 2 I use very light pencil marks on the watercolor paper, so next I emphasize the most important compositional lines with very thin mixtures of cerulean blue and Hooker's green.

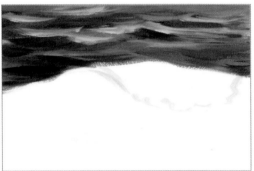

Step 3 I start painting the background waves, using Hooker's green and ultramarine blue for the water and titanium white and cerulean blue for the lighter reflections on the waves.

Artist's Tip

You need to be able to paint wet-on-wet to create gradual transitions from one color to the next. In order to do so, be sure to mix enough paint on your palette. If you do not have enough paint and need to mix more during the process, the paint on your paper will dry too fast.

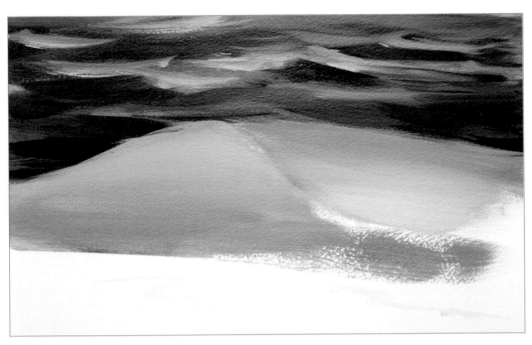

Step 4 Next I use a very light mixture of titanium white, cadmium yellow, and Hooker's green on the bottom of the falling part of the wave, making this mixture darker as I move up towards the top of the wave.

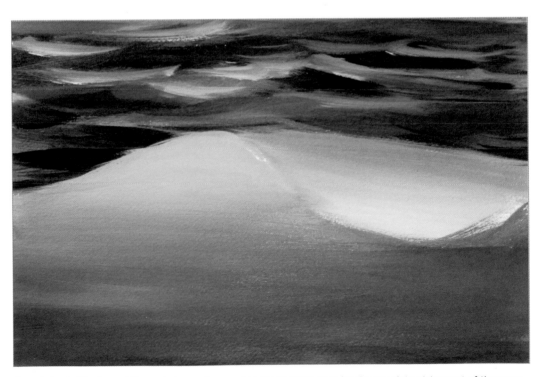

Step 5 I mix titanium white, cadmium yellow, and Hooker's green to paint the top of the rising part of the wave. As I work closer to the bottom of the wave, I darken the color by adding more ultramarine blue to the mix.

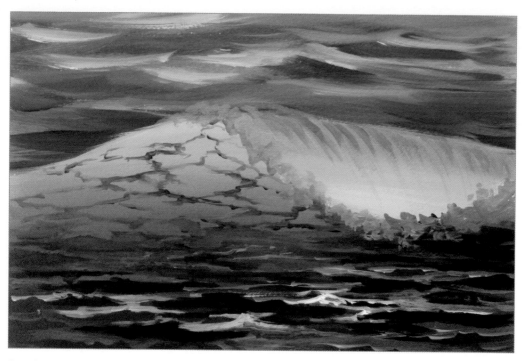

Step 6 Next I paint foam trails on both the rising part and the edge of the crashing part of the wave. For this step I use mostly midtone and darker mixtures of blues and greens. Remember that the foam in the shadow of the falling wave should be much darker than the foam on the top of the wave or in the foreground.

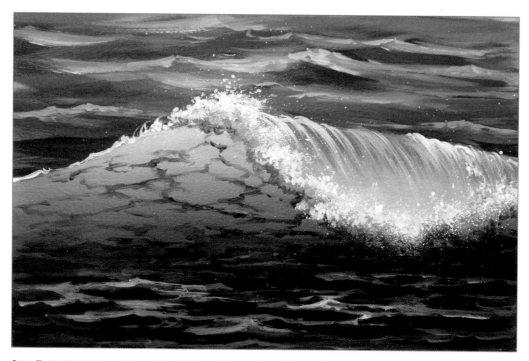

Step 7 I mix titanium white with a little cadmium yellow. Then I follow the spattering technique, using a toothbrush to create the foam splashes on the crashing wave.

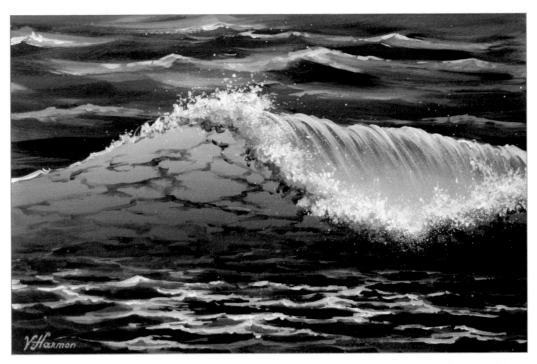

Step 8 For the final step, I use the same mixture from step 7 to emphasize the highlights on the tops of the waves and the sunlit foam. Try not to overdo in this step; otherwise you may lose your focal point, which is the crashing wave.

Detail

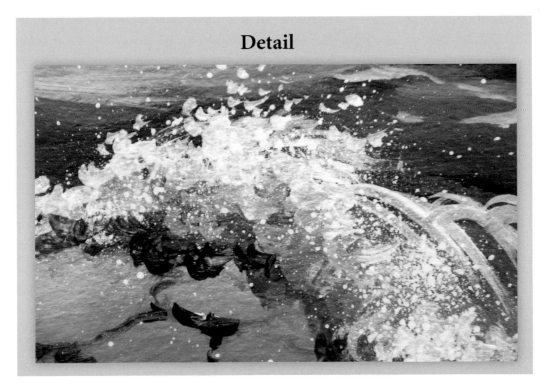

Painting a Seascape

Now we're going to take what we learned in the previous two projects and combine the techniques to paint a vibrant seascape.

Color Palette
ultramarine blue, cerulean blue, alizarin crimson, Payne's gray, burnt sienna, yellow ochre, Hooker's green, cadmium yellow, and titanium white

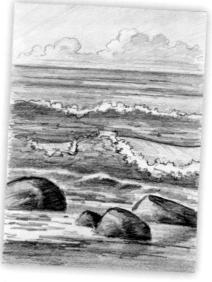

Step 1 First I create the composition, and then I transfer it onto the canvas.

Step 2 I start with the sky, working from the horizon up. I use titanium white, cerulean blue, ultramarine blue, and little bit of alizarin crimson. Closer to the horizon, the sky is lighter and pinkish. Toward the top of the canvas, the sky is darker, with more cerulean blue and ultramarine blue. Try to create smooth transitions from lighter to darker colors. Next I paint the shapes of the clouds, using titanium white, alizarin crimson, and cadmium yellow.

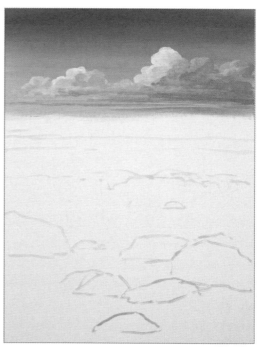

Step 3 I add some blues to the cloud mixture and create some shadows in the clouds. I also outline the location of the ocean waves and rocks on the beach.

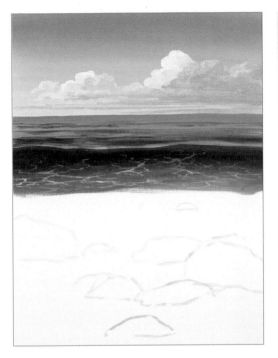

<div style="text-align:center">

Artist's Tip

Make sure your brushes are completely
clean of paint when you move on to a new step.
It is very easy to create "muddy" colors
on your canvas with a dirty brush.

</div>

◀ **Step 4** I start working on the background ocean.
The color closer to the horizon is lighter, so I use
more cerulean blue to reflect the sky. Then I create
the shape of the more distant wave and add thin
foam trails to the flat and rising parts of the wave.

▶ **Step 5** Next I add heavier foam to the top and
crashing part of the wave, using titanium white and
cadmium yellow.

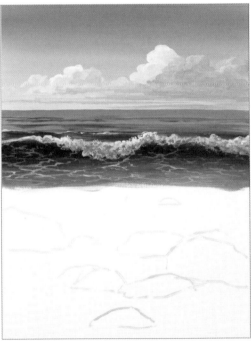

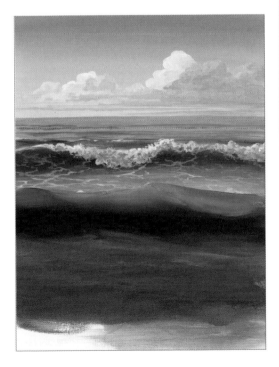

◀ **Step 6** I paint the wave closer to the shore, using
blue and green mixes of titanium white, cadmium
yellow, Hooker's green, and ultramarine blue. If
needed, refer to pages 56–59 to refresh your memory
on how to paint the wave.

61

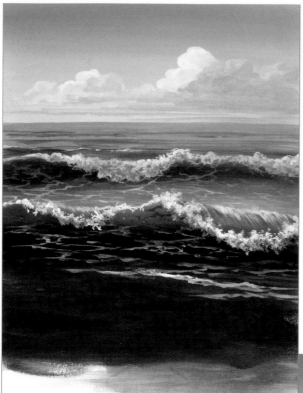

Step 7 I finish painting the second wave with foam details. Remember that foam trails in the shadow of a wave will be much darker than trails either on the top of a wave or on flat water.

Step 8 Next I paint the beach rocks and the sand with the rocks' reflections. I use ultramarine blue, Payne's gray, burnt sienna, and yellow ochre to paint the rocks, scraping off paint to create texture. I use the same colors to paint the sand, smoothing it with a flat brush.

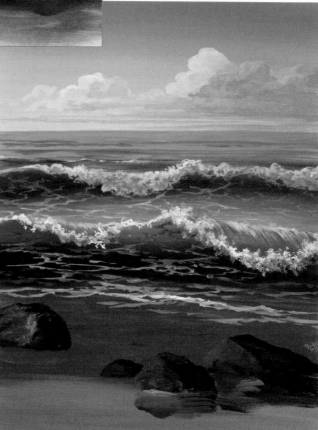

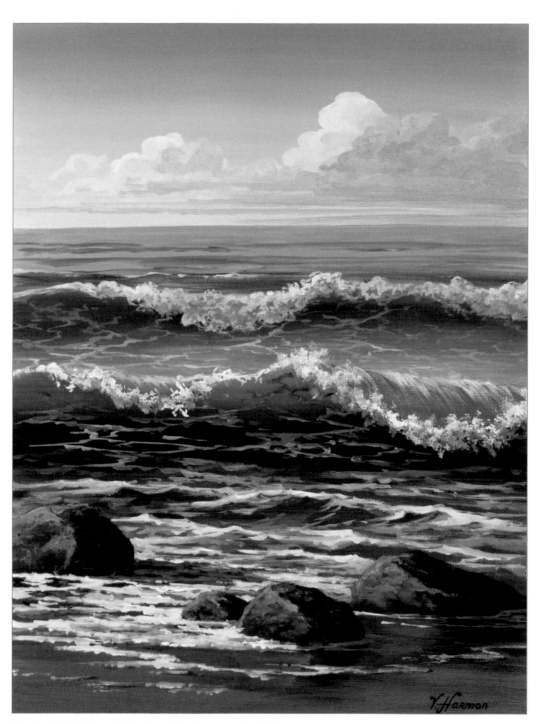

Step 9 I finish the painting by adding foam on the shallow water and between the rocks. Then I add a few thin foam trails in the wet sand.

Closing Thoughts

There's something I want you to consider: You will not become a great artist overnight. It takes a lot of time and practice to improve your skills. The good news is that anyone who wants to paint can do it—just be patient and keep working toward your goal! Some days will be easier that others, but do not be discouraged if you do not get the results you want and expect during your first, second, or third try. Save your early paintings, because when you look at them in a couple of years, you will see how well you have mastered your skills!

Good luck on your journey in discovering yourself as an artist! Remember to have fun with the experience, and never, ever give up!

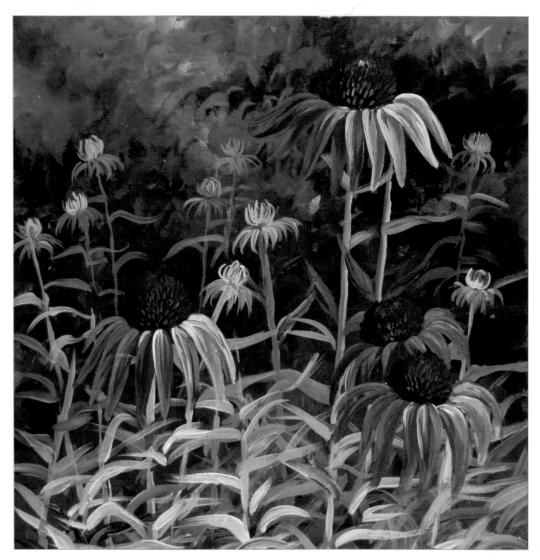